T0096501

 Published by Ice House Books

Copyright © 2020 Spencer Wilson
Courtesy of Yellow House Art Licensing
www.yellowhouseartlicensing.com

Concept by Spencer Wilson
Written & compiled by Spencer Wilson & Samantha Rigby

Ice House Books is an imprint of Half Moon Bay Limited
The Ice House, 124 Walcot Street, Bath, BA1 5BG
www.icehousebooks.co.uk

ISBN 978-1-912867-29-5

Printed in China

HOW
TO LOOK AT
ART

ICE HOUSE BOOKS

THERE ARE MORE
VALID FACTS AND
DETAILS IN WORKS OF
ART THAN THERE ARE
IN HISTORY BOOKS.

Charlie Chaplin

IN WINE LIES THE TRUTH.

Pliny the Elder

WE WERE TOGETHER, I FORGET THE REST.

Walt Whitman

STUDY WITHOUT DESIRE SPOILS THE MEMORY, AND IT RETAINS NOTHING THAT IT TAKES IN.

Leonardo da Vinci

ART IS WHAT YOU CAN GET AWAY WITH.

Andy Warhol

ART HAS SOMETHING TO DO WITH AN ARREST OF ATTENTION IN THE MIDST OF DISTRACTION.

Saul Bellow

MY GOAL AS AN ARTIST IS TO CREATE ART THAT MAKES PEOPLE LOOK AT THE WORLD IN A DIFFERENT WAY.

Autumn de Forest

THROUGH A LENS

WE ARE MAKING PHOTOGRAPHS TO UNDERSTAND WHAT OUR LIVES MEAN TO US.

Ralph Hattersley

WHETHER YOU
SUCCEED OR NOT
IS IRRELEVANT, THERE
IS NO SUCH THING.
MAKING YOUR
UNKNOWN
KNOWN IS THE
IMPORTANT THING.

Georgia O'Keeffe

IN PUZZLEMENT

YOU HAVE TO SYSTEMATICALLY CREATE CONFUSION. IT SETS CREATIVITY FREE.

Salvador Dali

WE DON'T MAKE MISTAKES, JUST HAPPY LITTLE ACCIDENTS.

Bob Ross

CRITICALLY

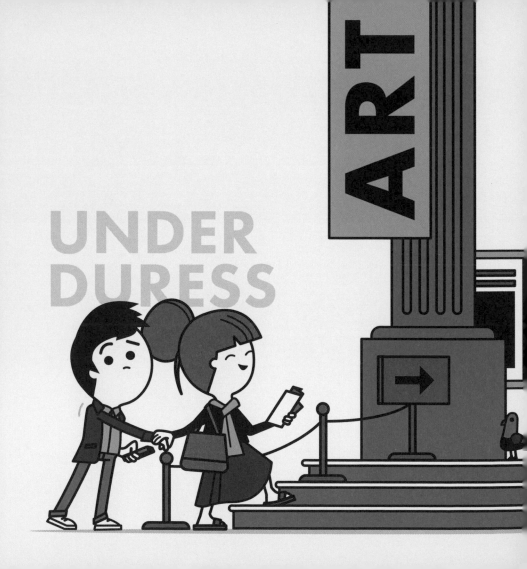

ART IS TOO IMPORTANT NOT TO SHARE.

Romero Britto

ART ENABLES US
TO FIND OURSELVES
AND LOSE OURSELVES
AT THE SAME TIME.

Thomas Merton

AT LENGTH

FOR
REASSURANCE

YES, IT'S TRUE, I'M HERE, AND I'M JUST AS STRANGE AS YOU.

Frida Kahlo

EVERY CHILD IS AN ARTIST. THE PROBLEM IS HOW TO REMAIN AN ARTIST ONCE WE GROW UP.

Pablo Picasso

THROUGH A
CHILD'S EYES

AS A FAMILY

I LIKE KIDS' WORK MORE THAN WORK BY REAL ARTISTS ANY DAY.

Jean-Michel Basquiat

ANY FOOL CAN KNOW. THE POINT IS TO UNDERSTAND.

Albert Einstein

MY WORK IS UTTERLY
INCOMPREHENSIBLE
AND IS THEREFORE
FULL OF DEEP
SIGNIFICANCE.

Bill Watterson

STYLISHLY

LOUDLY

THE WORST ENEMY TO CREATIVITY IS SELF-DOUBT.

Sylvia Plath

A PICTURE IS A POEM WITHOUT WORDS.

Horace

DEEPLY

I DREAM MY PAINTING AND THEN I PAINT MY DREAM.

Vincent van Gogh

CURIOSITY ABOUT LIFE IN ALL OF ITS ASPECTS, I THINK, IS STILL THE SECRET OF GREAT CREATIVE PEOPLE.

Leo Burnett

CURIOUSLY

ART
TRANSCENDS
CULTURAL
BOUNDARIES.

Thomas Kinkade

A SIMPLE LINE PAINTED WITH THE BRUSH CAN LEAD TO FREEDOM AND HAPPINESS.

Joan Miró

HOPEFULLY

TRASH HAS GIVEN US AN APPETITE FOR ART.

Pauline Kael

HUNGRILY

EVERYBODY MUST HAVE A FANTASY.

Andy Warhol

I DON'T BELIEVE IN LOVE, BUT I BELIEVE IN YOU.

Tracey Emin

TOGETHER

THE BIT ABOUT US

**Illustrator, designer and inventor of this book,
Spencer Wilson** likes to visit museums and galleries
when he can find time. As his mind wanders he will
often sit and silently observe how others look at the
art around them, taking notes in his sketchbook.

Samantha Rigby runs things at Ice House Books
and spends most days looking at art on book covers.
In her spare time, she's been known to stroll around
a gallery or two, discovering the stories in the art.

@spencerwilson8

www.spencerwilson.co.uk

The Modern Mamil:
How To Look Pro

ISBN 978-1-912867-09-7

Jog On: A Journal for
Women Who Run

ISBN 978-1-912867-08-0

Homeworking:
The Ultimate Guide

ISBN 978-1-912867-72-1